BIG RIGS

BIG RIGS

Hope Irvin Marston

Illustrated with color photographs

REVISED AND UPDATED EDITION

COBBLEHILL BOOKS *Dutton New York*

The photographs in this book are used by permission and through the courtesy of: Bekins Van Lines Company, 22; Cummins Engine Company, Inc., 18; EAST Manufacturing Corporation, 26; Ford Motor Company, 6, 8, 12, 13, 19, 20, 37; Freightliner Corporation, 14, 38; Kenworth Truck Company, 40; Mack Trucks, Inc., 16, 41, 48; Marmon 42; Hope Irvin Marston, 11; Navistar International Transportation Corporation, 15, 29, 39; Oshkosh Truck Corporation, 31, 32, 33, 43; Osterlund, Inc., 36; Peterbilt Motors Company, 28, 44; Schneider National, 10; Howard Scott, 25; TRAIL KING Industries, Inc., 30; TruckShots, 34, 35; Volvo GM Heavy Truck Corporation, 21, 23, 45; Wilson Trailer Company, 9, 24.

Library of Congress Cataloging-in-Publication Data
Marston, Hope Irvin.
Big rigs / Hope Irvin Marston. — Rev. and updated ed. p. cm.
Summary: Describes various kinds of tractor-trailer combinations, the biggest trucks on the highway.
ISBN 0-525-65123-3
1. Tractor trailer combinations—Juvenile literature. [1. Tractor trailers. 2. Trucks.] I. Title.
TL230.M365 1993 629.224—dc20 92-39881 CIP AC

Published in the United States by Cobblehill Books,
an affiliate of Dutton Children's Books,
a division of Penguin Books USA Inc.,
375 Hudson Street, New York, New York 10014

Printed in Hong Kong
First Edition 10 9 8 7 6 5 4 3

To J. Peter Mosling,

Oshkosh Truck Corporation

The author wishes to thank three professional truck drivers for their assistance in updating this edition of Big Rigs: *Ray Byler, Richard Muthler, and Brian Kenwell.*

What is a big rig?

A big rig is the biggest kind of truck you will see on the highway. It is a truck with two parts—a tractor and a trailer.

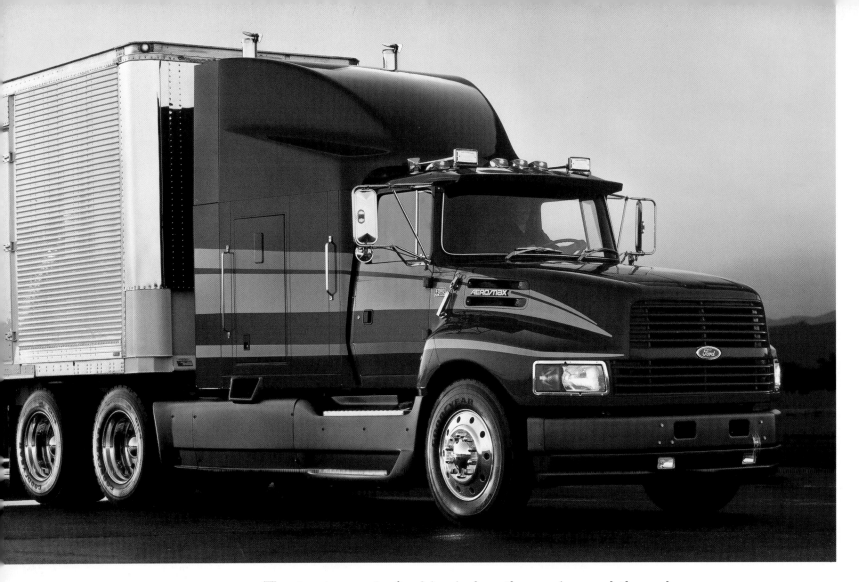

The tractor part of a big rig has the engine and the cab where the driver sits. The trailer is attached behind the cab. It is supported by two axles on the tractor, each with double sets of wheels.

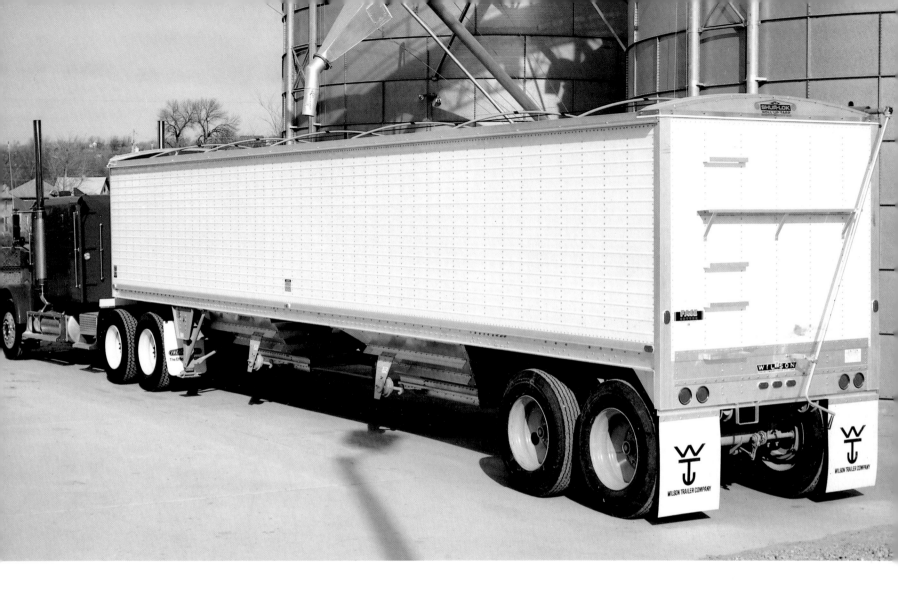

The trailer is the part where the load is carried.

Most trailers have no front wheels—only wheels at the rear. They are called semi-trailers, or "semis," for short.

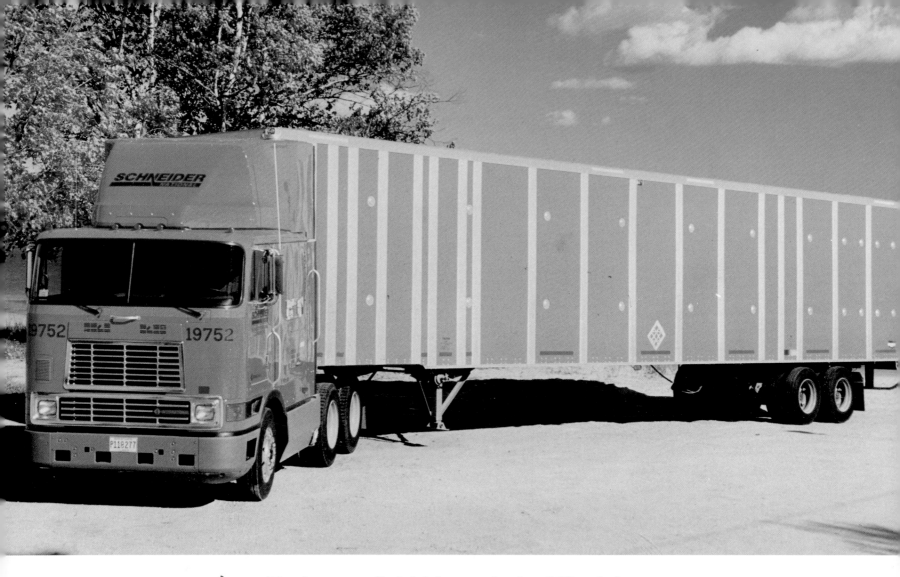

Big rigs are called "eighteen-wheelers." That is because most of them have ten wheels on the tractor and eight wheels on the semi-trailer.

The next time you see a big rig, count the wheels!

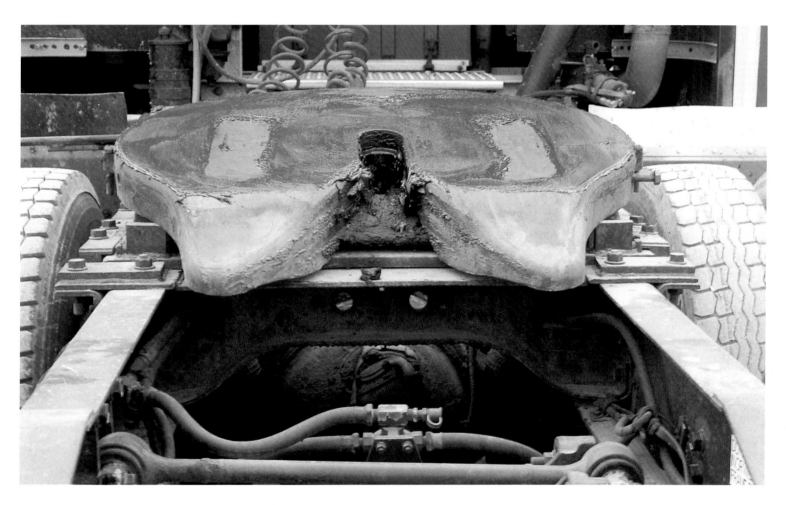

The tractor is hitched to the semi by a "fifth wheel." The fifth wheel is a heavy, round plate with a hinge. A steel bolt in the trailer floor fits into the notch in the fifth wheel and locks it into place. That lets the trailer turn freely behind the tractor.

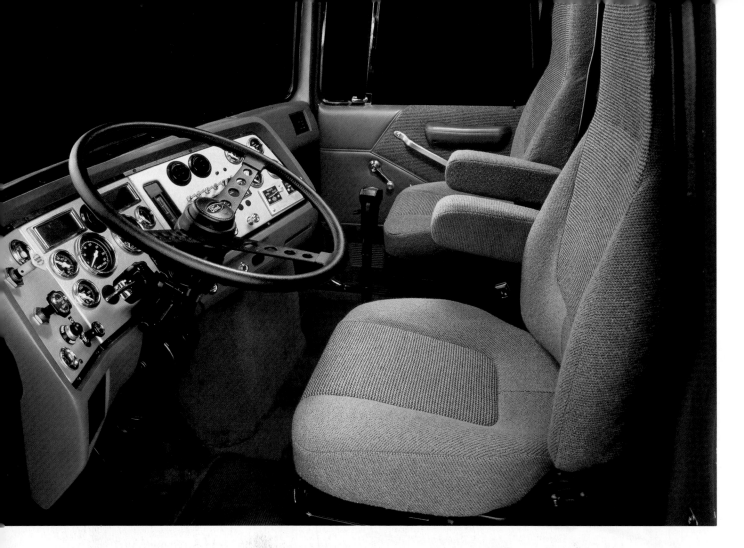

Inside the cab of the tractor there is lots of space. The driver looks out through a big, tinted windshield that curves around to give a clear view.

The steering wheel is almost flat. That makes it easier to handle.

A good driver knows how to get the most power out of his engine. He slows it down by applying his powerful air brakes. When he releases air into the brakes, there is a loud SWOOSH!

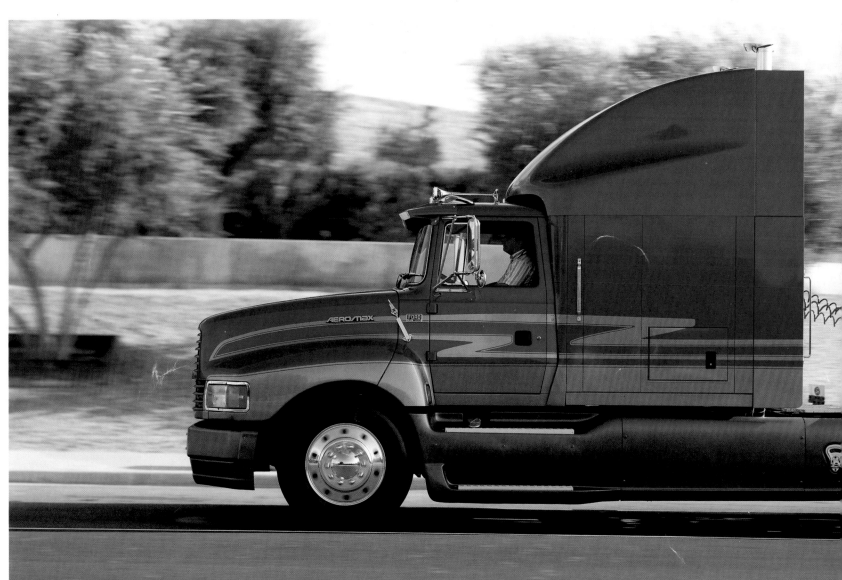

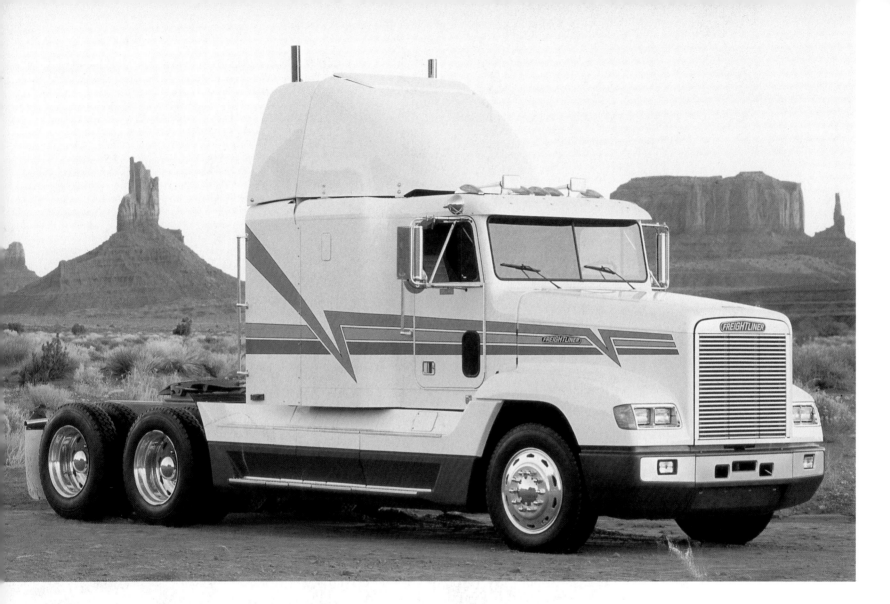

Big rigs are pulled by two kinds of tractors. In a "long nose" or "conventional" tractor, the engine is built out in front of the cab.

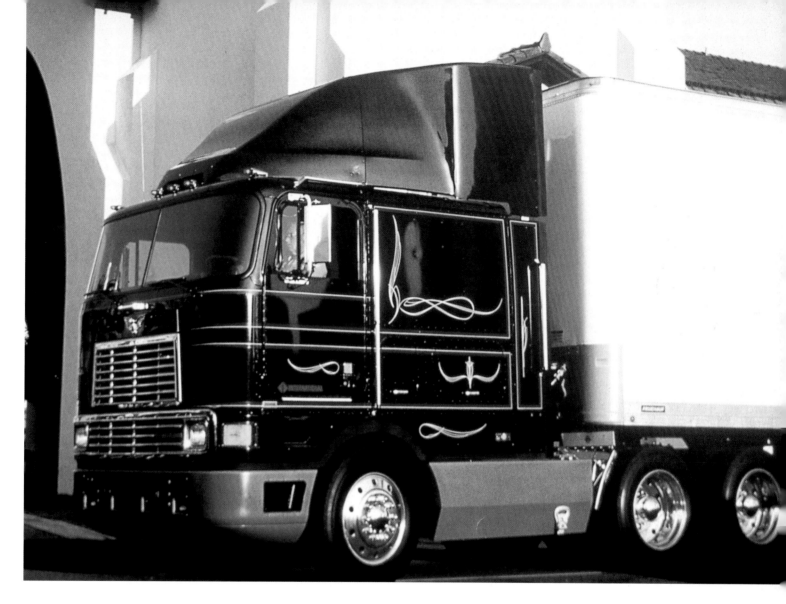

When the engine is located under the cab, it is called a "snub nose" or C-O-E (cab-over-engine). The cab tilts up to get at the engine.

Most big rigs burn diesel fuel instead of gasoline. They have one or two smokestacks to let the fumes from the burned fuel escape. You can smell the fumes when a diesel tractor goes by.

Sometimes the smokestacks on a big rig make a loud, growling sound. When this happens on a Mack truck, the driver says his smokestacks are "barking." That's because the emblem of his Mack truck is a bulldog.

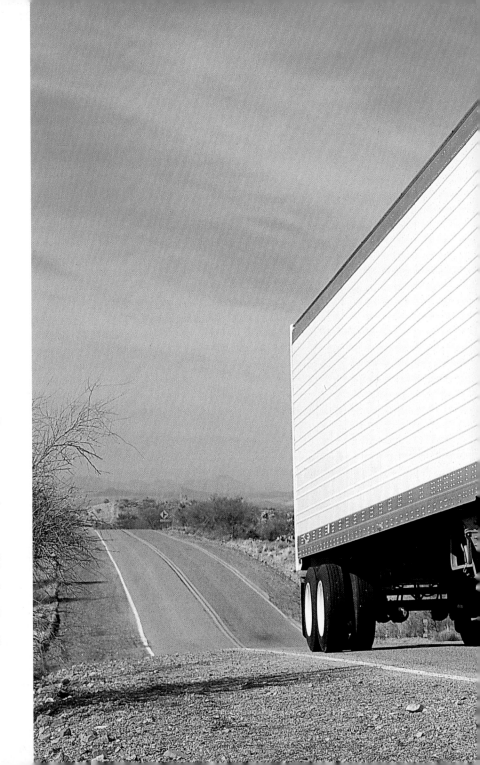

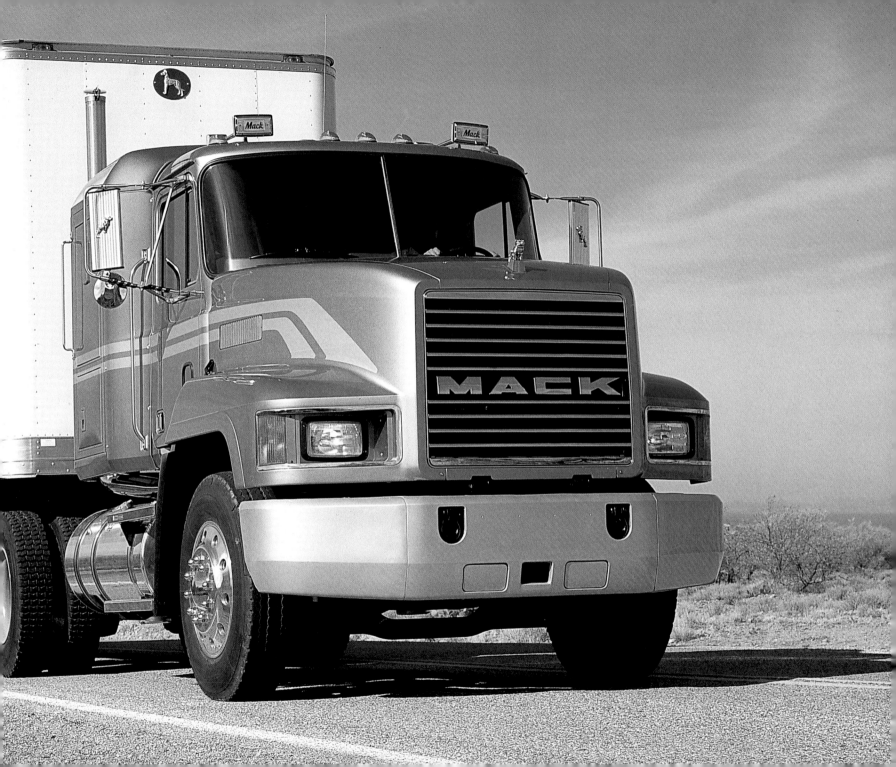

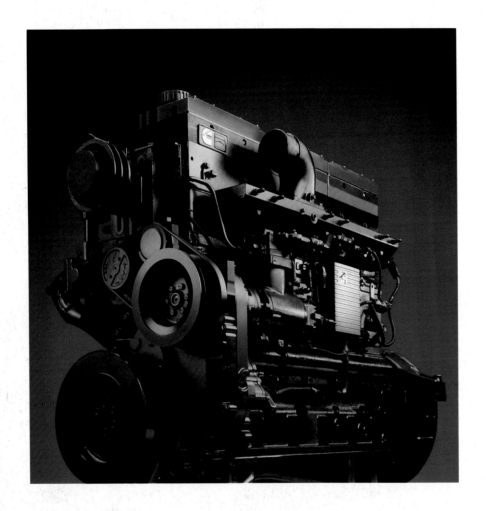

The diesel engine is controlled by electronics. Modern diesel engines have cruise control and speed limiting. This means that you can't drive faster than a pre-set speed.

This is what a big tractor looks like inside. It has many parts working together.

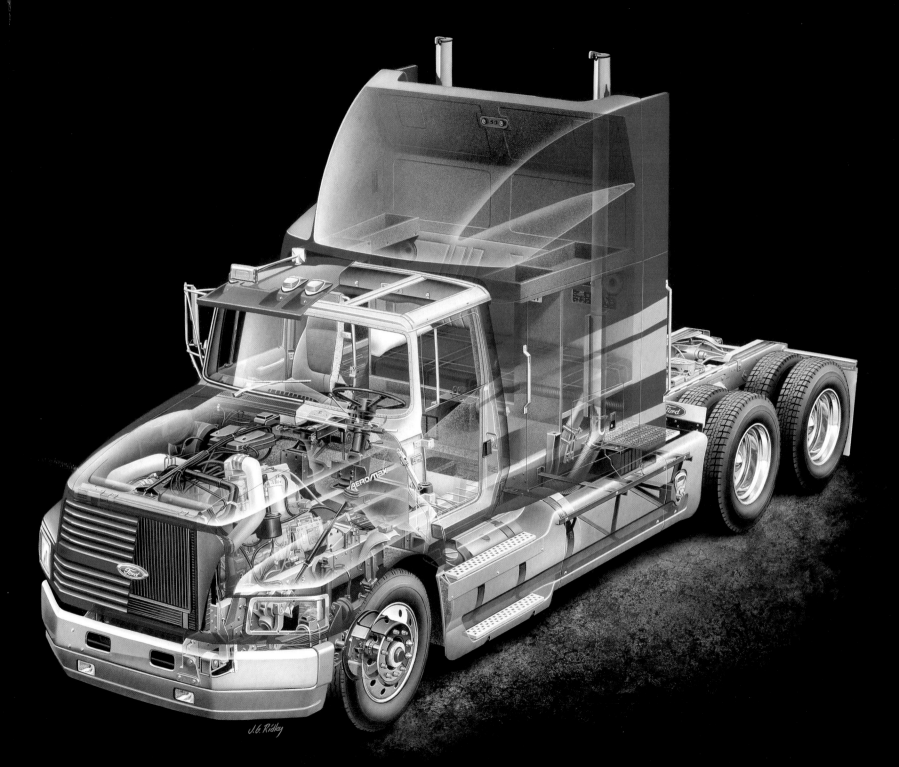

J.G. Ridky

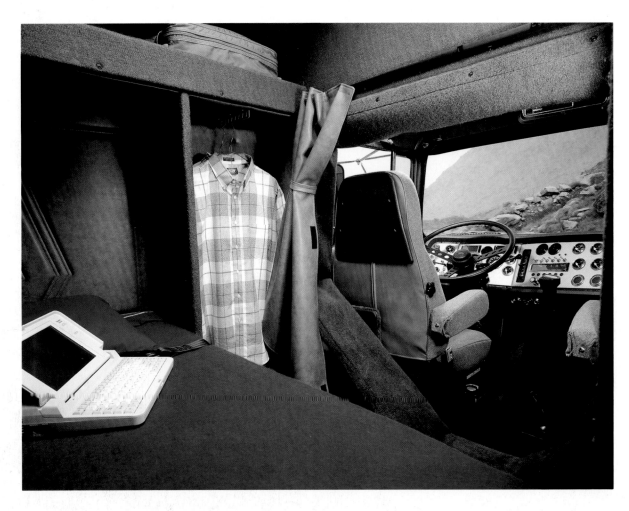

Some tractors are called "sleepers." They have a built-in bed behind the driver's seat. One driver sleeps while the other drives. A trucker without a partner pulls off the highway to sleep.

Other tractors have bunk sleepers with room for two people. When driving partners are waiting to get unloaded or loaded, both can sleep.

Sometimes driving partners are a husband and wife. Four out of every hundred drivers are women.

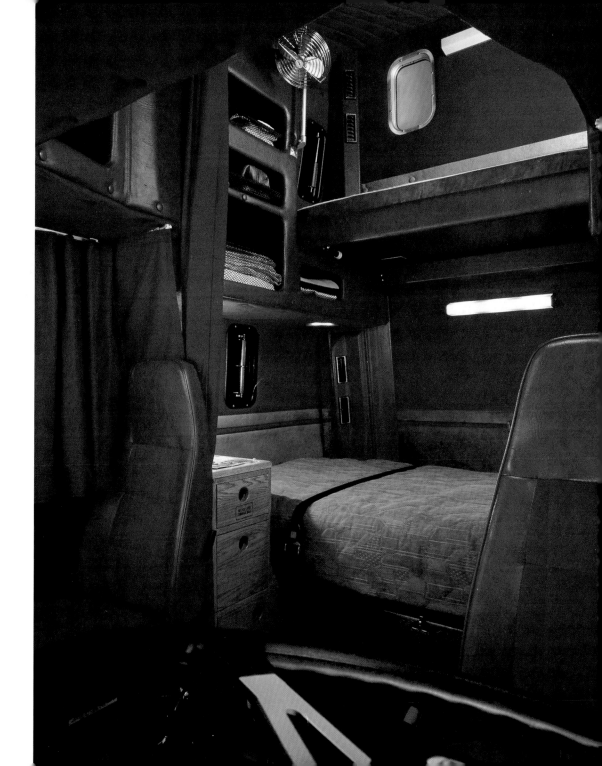

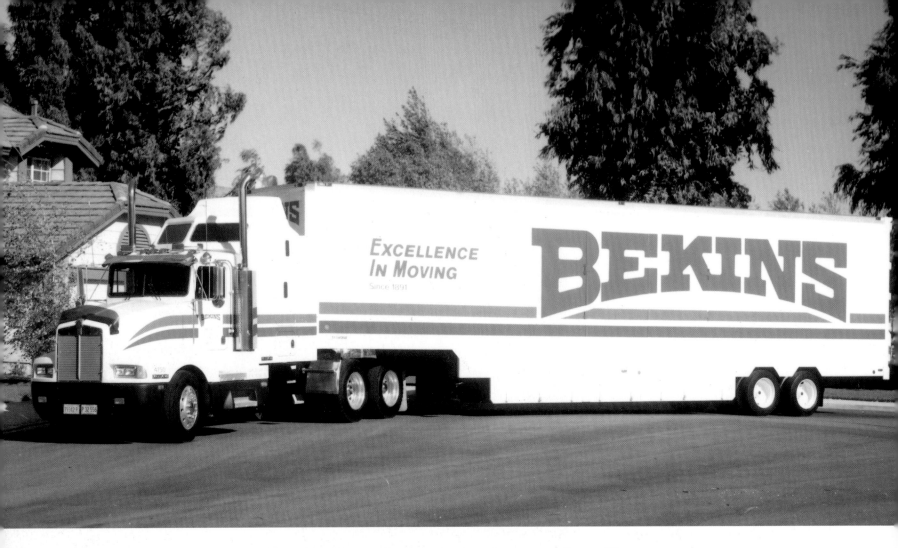

Tractors pull different kinds of semi-trailers. The most common type is the long, rectangular box. It is called a van. Vans haul freight like furniture, clothing, tools, books, toys.

This van carries people's belongings when they move from city to city or across the country.

A "reefer" is a refrigerated van. It carries fresh fruit, flowers, medicine, or other things that need to be kept cool. The refrigeration unit is attached to the front of the van.

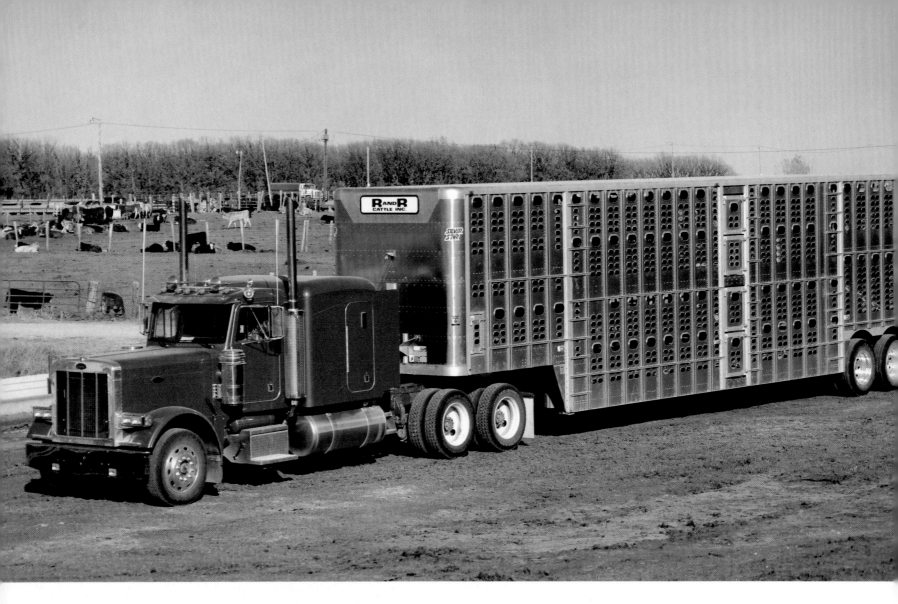

A livestock hauler carries cattle, sheep, or hogs to market.
When a "drop frame" makes the floor level lower between the
axles than it is directly over them, it's called a "possum belly."

Big rigs are very strong. They carry tons of cargo. Some deliver new cars and trucks to dealers.

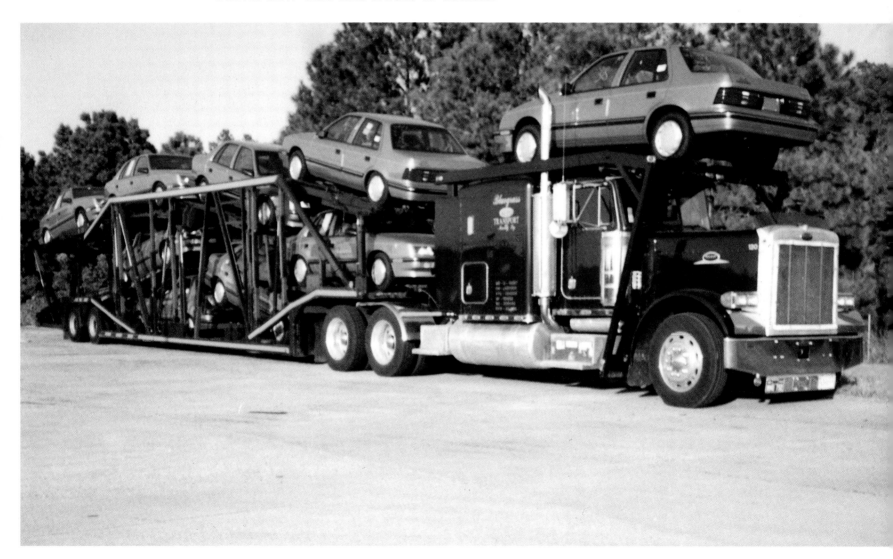

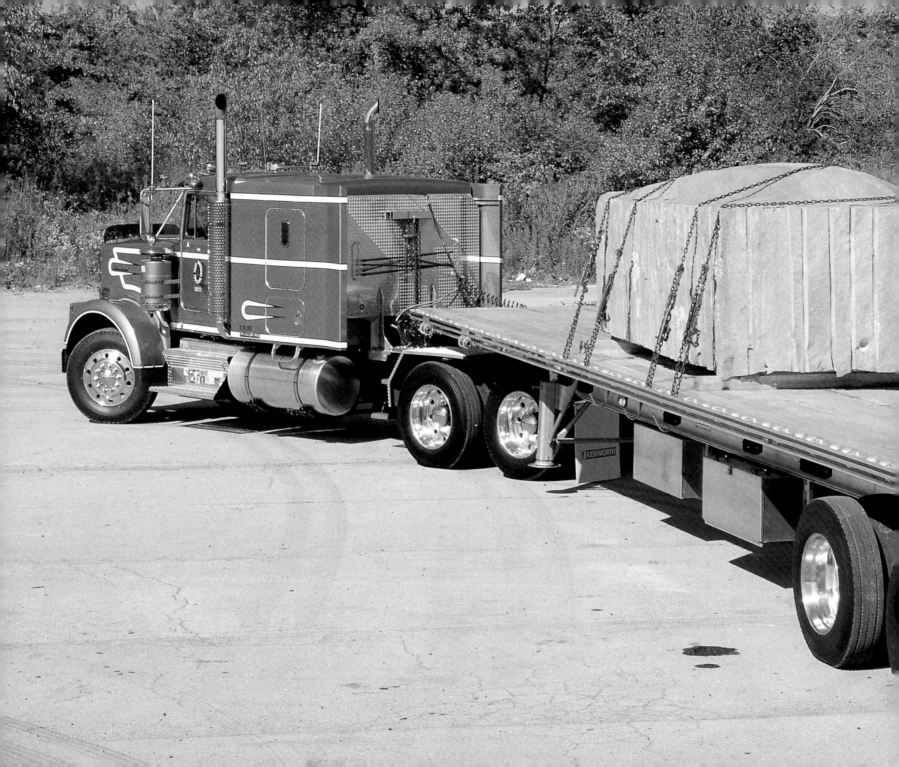

Flatbed semis have a flat bottom like a platform. They have no sides, so they can carry odd-shaped products. Their cargo is tied down with heavy ropes, chains, or cables. Sometimes it is covered with canvas to protect it in bad weather.

This flatbed can haul 60,000 pounds.

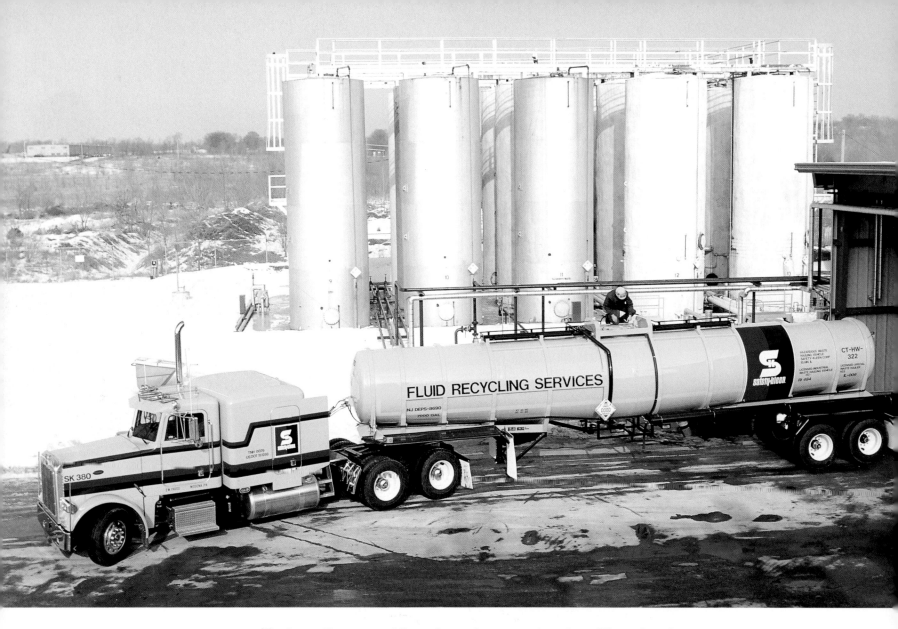

Tank trailers are like giant thermos bottles. They haul
gases or liquids such as milk, molasses, chemicals, and fuel.

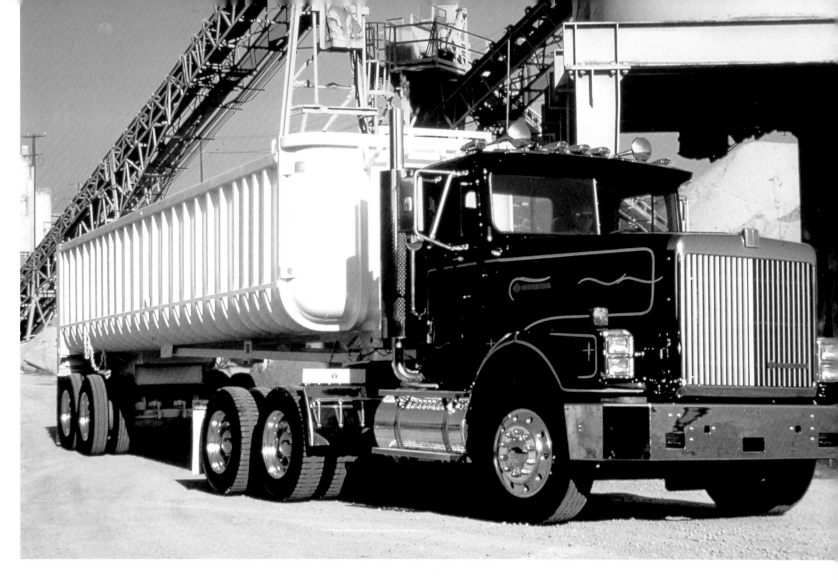

Dump trailers can be tilted up to empty their cargo. They carry things like coal, gravel, rocks, and sand.

Some trailers that carry grain are unloaded through the bottom.

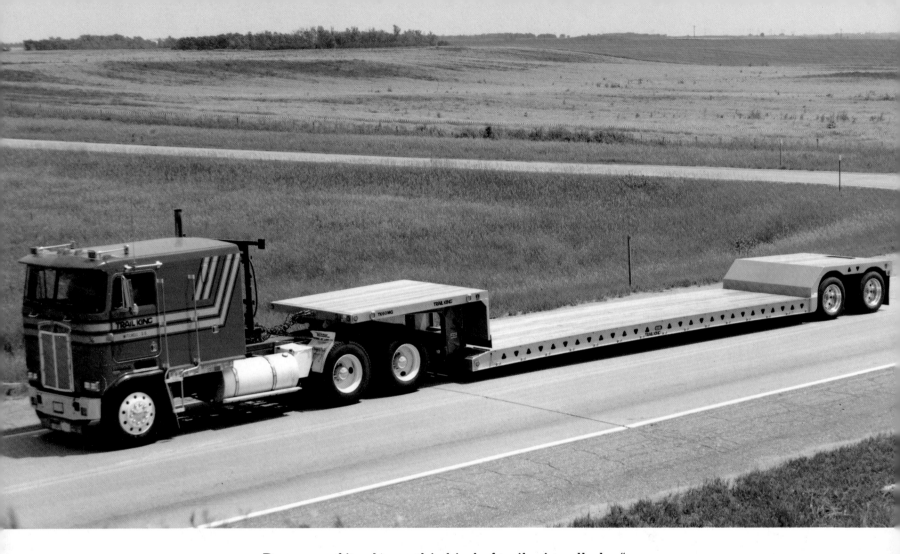

Because of its shape, this kind of trailer is called a "goose-neck" or "lowboy." Since it is built low to the ground, it's easy to load it with heavy or bulky cargo.

Tractor trailers need government permits to move loads that weigh more than 80,000 pounds.

This concrete carrier can deliver more concrete per hour and discharge it faster than other kinds of concrete mixers. The silver paint deflects heat to keep the temperature of the concrete constant during hot weather.

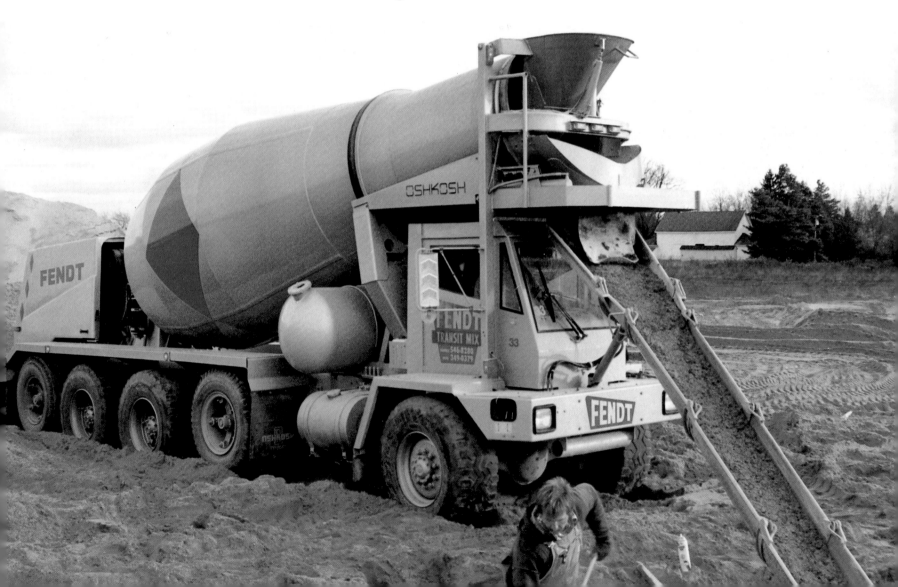

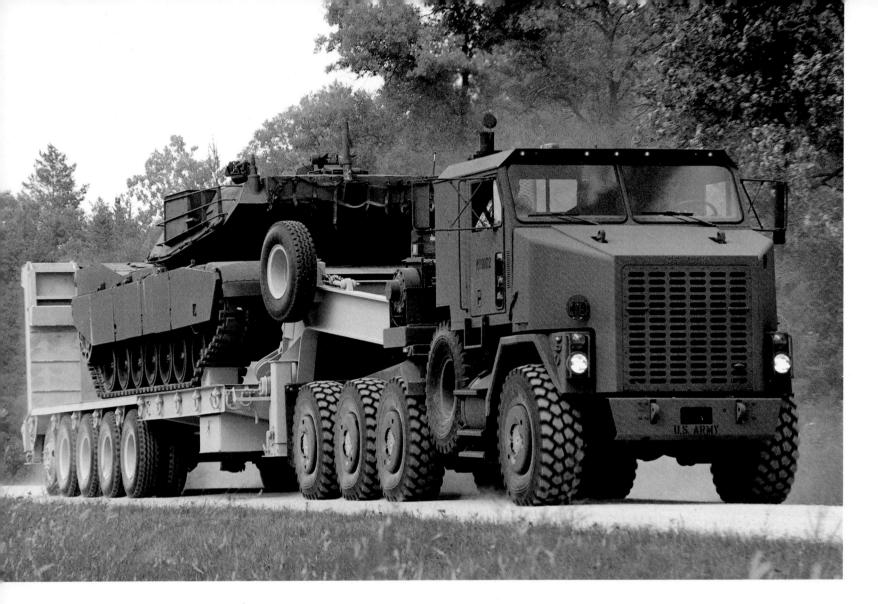

Companies that make the big rigs we see on our highways
also make transporters used by the military. This heavy-duty
one proved useful in the Gulf War.

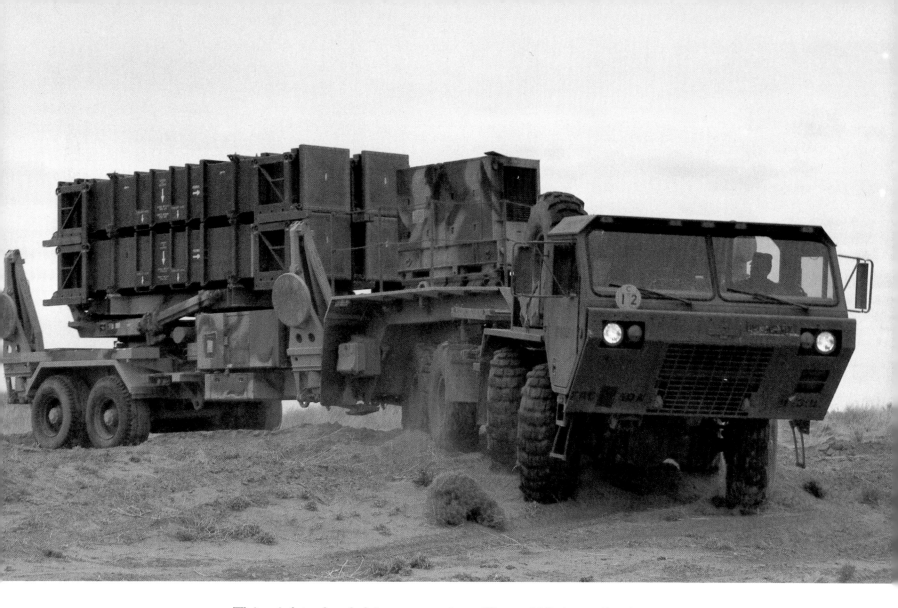

This eight-wheel-drive tractor is pulling a U.S. Army Patriot
missile-launching platform. It is known as the HEMTT
(Heavy Expanded Mobility Tactical Truck).

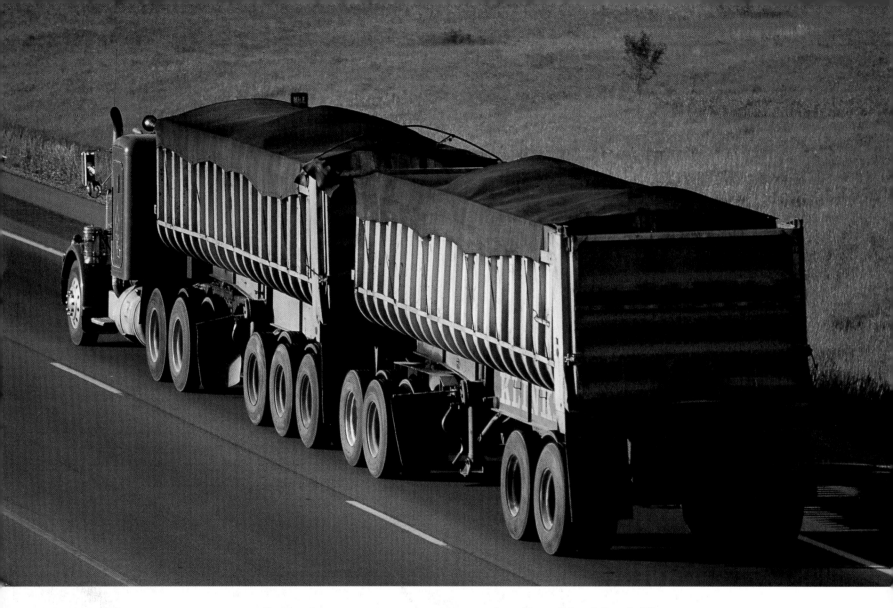

Sometimes you see a tractor hauling "doubles." That means the tractor is pulling two trailers. A short trailer is called a "pup."

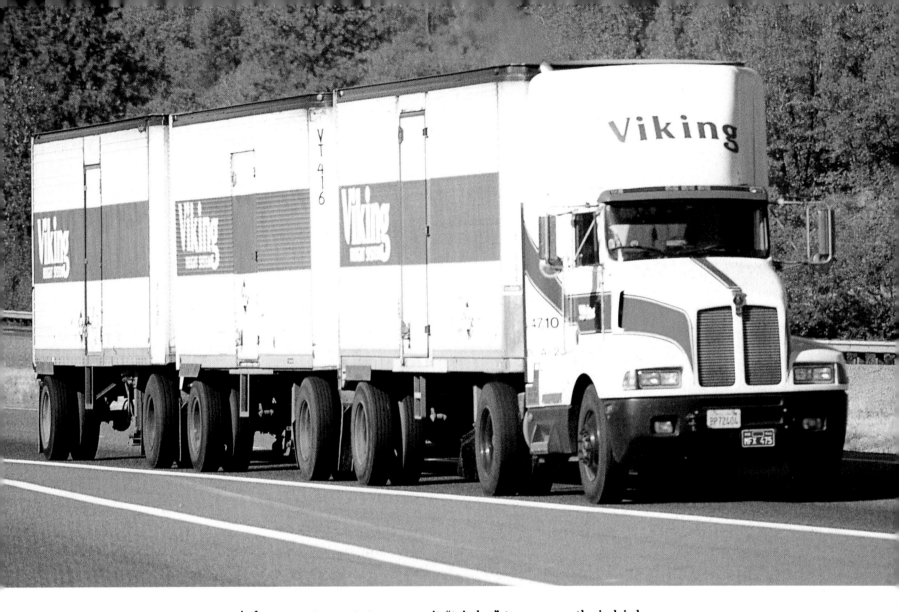

A few western states permit "triples" to run on their highways because the roads run straight for mile after mile. A triple is a tractor, a semi, and two pups.

You can get to know the different makes of tractors by their emblems and their grills.

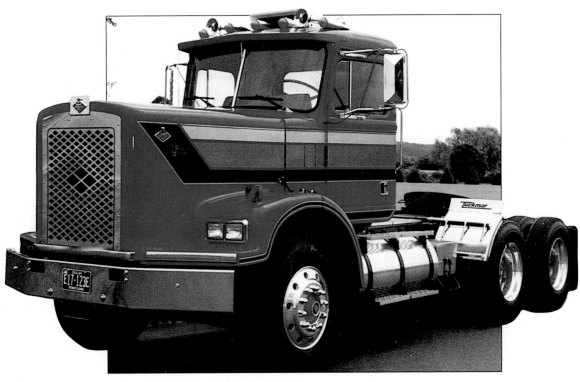

The newest Diamond Reo tractors have diamond-shaped openings on their grills. The diamond-shaped emblem is at the top.

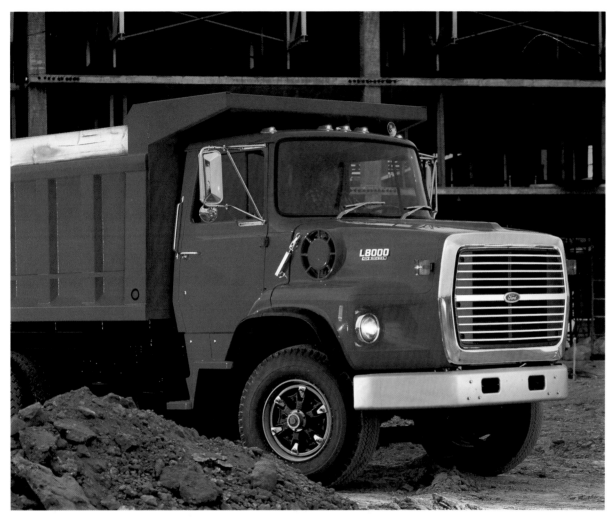

Look for the "flying saucer" emblem in the middle of the Ford tractor grill. Some models have a strip across the grill with the name "Ford" on it.

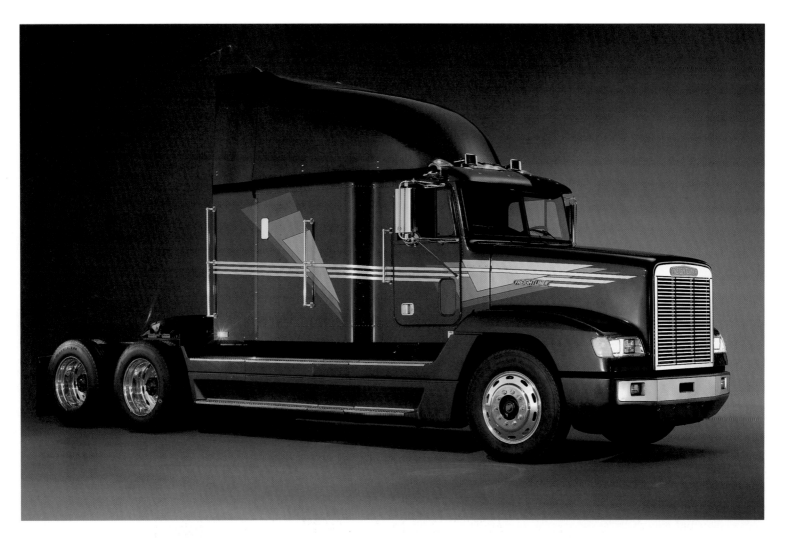

The shape of the emblem and the length of the name make it easy to recognize Freightliner tractors. The emblem looks like a long hot dog with a hump in the top.

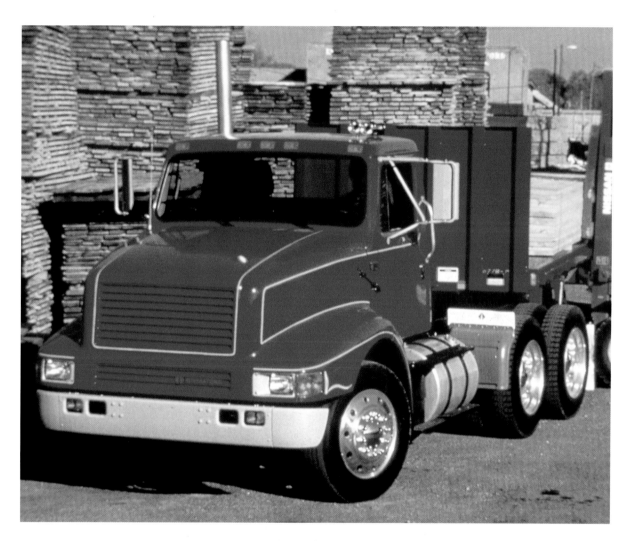

The grills on International tractors do not all look alike. But the emblem and the word International are on all models.

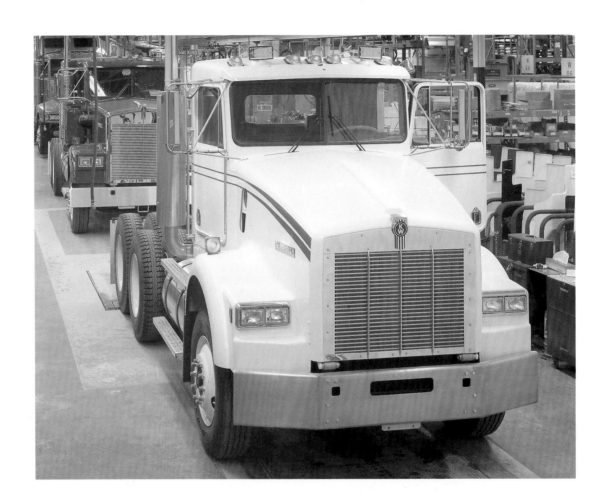

The Kenworth tractor is called a "K-Whopper" or a "KW"
because of its emblem above the grill.

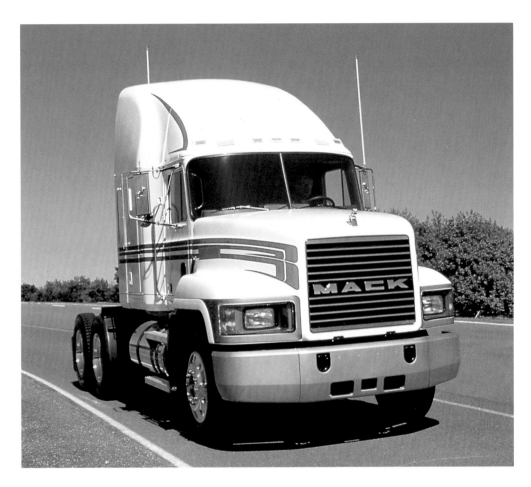

You can tell a Mack tractor by its bulldog. Not all Mack tractors look the same. They may have different-shaped cabs, grills, or hoods. But each one has the bulldog riding up front on the hood where he can see everything first.

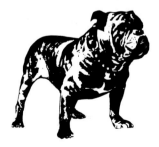

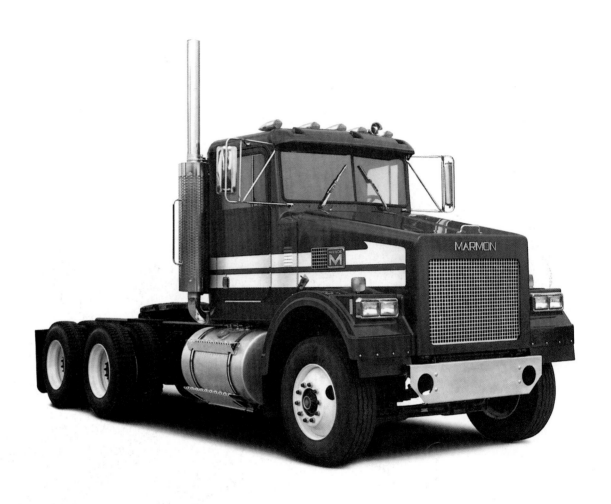

You can't miss the big red "M" on a Marmon tractor.

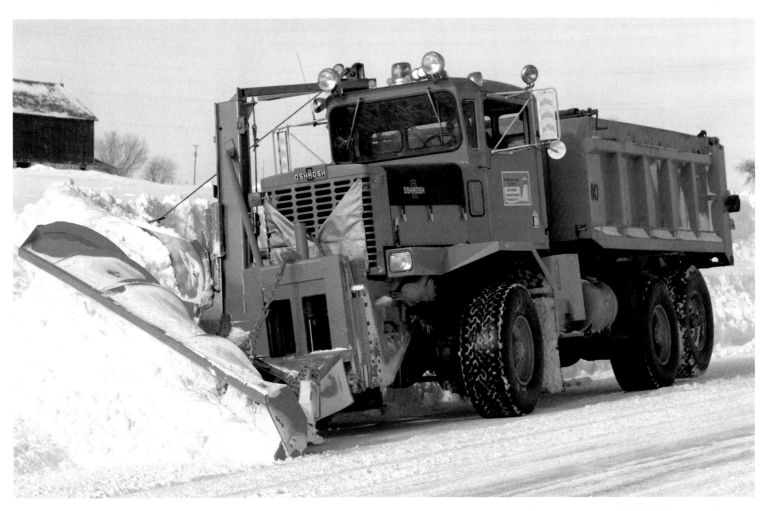

The Oshkosh "O" on a snowplow is a welcome sight when you're snowbound.

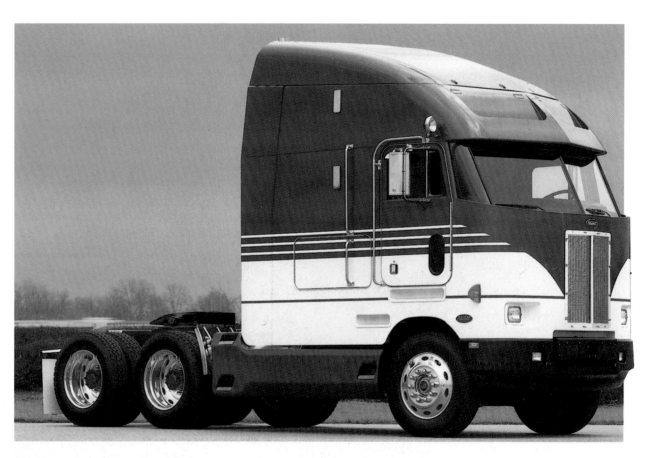

Look for the Peterbilt oval above the grill.

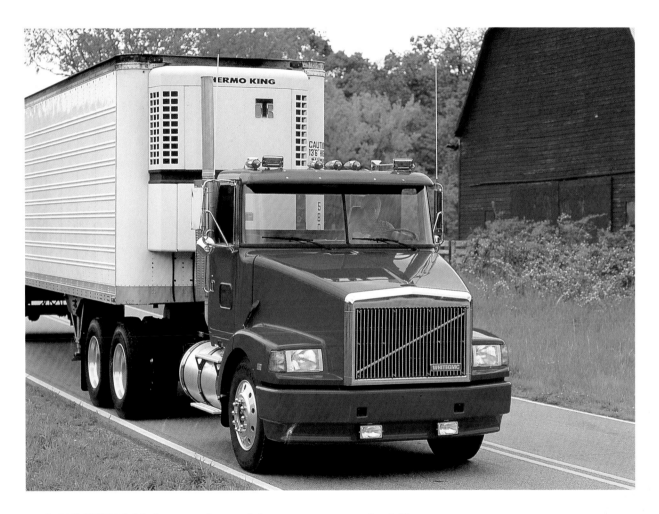

A WHITEGMC has a slanted bar across vertical lines on the grill. The emblem is in the lower right corner.

CB Radio Talk

Truck drivers use CB (Citizens Band) radios. Drivers tell each other about traffic tie-ups or accidents or that a police car is coming. Sometimes they just talk to each other when they are driving alone. When you listen to them, you hear strange words. Here are some terms you may enjoy knowing.

Alligator–A strip of retread along the highway.

Back down–To reduce speed.

Bird dog–Radar detector.

Bobtail–To drive a tractor without a semi-trailer attached.

Boom wagon–A truck loaded with explosives.

Bubble machine–A patrol car with light and siren on its roof.

Cackle crate–A truck that hauls live poultry.

Cat's eyes–The reflectors on "lollipop sticks."

Coffeepot–Restaurant.

Coffin box–A sleeper added to a conventional cab.

Double nickels–The 55 miles-per-hour speed limit.

Eskimo–A trucker who drives with his windows open in winter.

Got your ears on?–Are you listening to your CB radio?

Green stamps–Money paid for fines.

Hammer down–To go flat-out speed or "All she will do!"

Lollipop sticks–Slender posts with safety reflectors that mark the edge of the highway.

Piggy bank–A toll booth.

Picture taker–A radar speed trap.

Portable parking lot–An auto carrier.

Pumpkin–A flat tire. Also an orange Schneider National tractor-trailer.

Ratchet jaw–A driver who talks constantly on the CB radio.

Riding shotgun–Riding in the passenger seat.

Set it down–To stop quickly.

Shake the lights–To blink headlights as a warning.

Smokey Bear–Any police officer.

Vulture–A spotter plane that circles over highways to observe speeders.

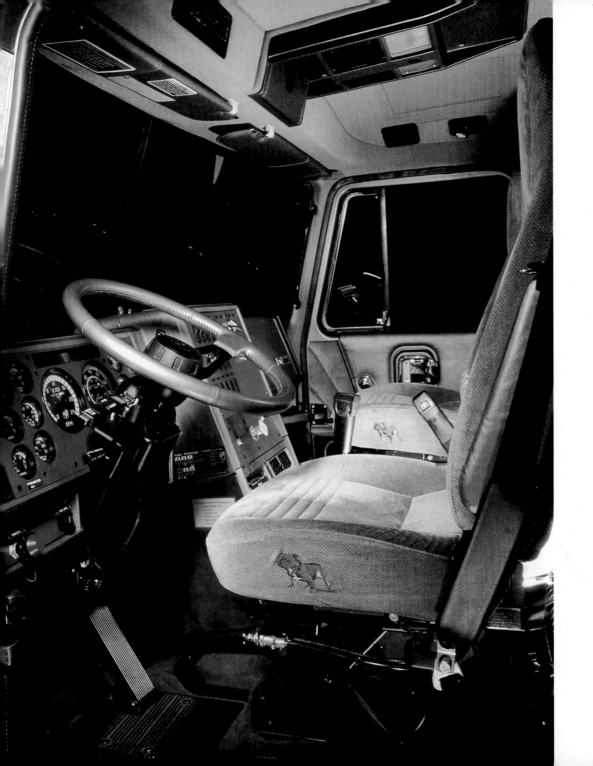

This seat is reserved for you. Learn all you can about big rigs. You may want to be a truck driver when you grow up.